The

ART LOVER'S
QUOTATION
BOOK

The
ART LOVER'S
QUOTATION
BOOK

An Inspired Collection on
Art, Beauty & Creativity

hatherleigh
Improve your life. Change your world.

Improve your life. Change your world.

Hatherleigh Press is committed to preserving and protecting
the natural resources of the earth. Environmentally responsible
and sustainable practices are embraced within the
company's mission statement.

Visit us at www.hatherleighpress.com and register online
for free offers, discounts, special events, and more.

Interior design by Cynthia Dunne

Printed in the United States
10 9 8 7 6 5 4 3 2 1

CONTENTS

INTRODUCTION

*A*rt teaches us to see into things, the great cultural critic Walter Benjamin wrote. Art, Benjamin argued, is about vision, about penetrating and understanding the world and people around us. Art is about being human.

What follows is a collection of quotations and epigrams about art for art lovers. Two hundred observations by painters and sculptors, novelists and photographers, filmmakers and philosophers, about art and how it teaches us to see…to the best of our limited abilities.

You will read about the purpose of art; about how it demands courage and vulnerability; about the artist's almost impossible quest for perfection; and about the need for a willingness to discover. By these rubrics, to be an artist is a sacred duty. Artists are a

combination of philosopher, provocateur, and priest; or, as Gerhard Richter said, Artists are the most important people in the world.

You will also read about the anguish that comes with being an artist. Artists feel misunderstood, undercompensated, and generally miserable: the suffering, impoverished artist is a perennial figure in our cultural landscape.

But you will also encounter sheer joy—the artist's fundamental joy in knowing that what he or she makes and does and says has meaning, and that being an artist and creating beauty, crafting meaning, is as close to paradise as we can come on earth.

Making art can be difficult, painful, and personally expensive. But it's also something to be ardently desired, for as long as humanly possible. As Jean-Baptiste Camille Corot noted wistfully, I hope with all my heart there will be painting in Heaven.

THE
PURPOSE
OF
ART

What compels artists to create? For some, it's a survival mechanism; for others, a means of expression, of searching for truth and meaning. Creating art touches on human attitude, individual desire, and our common aspirations and fears. A very tall order, especially when one is working with inert materials like paint or clay, which must be coaxed into coherence. Maurice Denis put it best: Remember that a picture, before being a battle horse, a nude, an anecdote or whatnot, is essentially a flat surface covered with colors assembled in a certain order. The goal of every artist is to somehow achieve that certain order. Again and again.

Art is man's constant effort to create for himself a different order of reality from that which is given to him.

—CHINUA ACHEBE

Art is an experience, not an object.

—ROBERT MOTHERWELL

We have art in order not to die of the truth.

—FRIEDRICH NIETZSCHE

I am interested in art as a means of living a life; not as a means of making a living.

—ROBERT HENRI

I found I could say things with color and shapes that I couldn't say any other way— things I had no words for.

—GEORGIA O'KEEFE

I paint flowers so they will not die.

—FRIDA KAHLO

I used to think that I could never lose anyone if I photographed them enough. In fact, my pictures show me how much I've lost.

—NAN GOLDIN

Every time I paint a portrait I lose a friend.

—JOHN SINGER SARGENT

The unfed mind devours itself.

—GORE VIDAL

I don't paint to live, I live to paint.

—WILLEM DE KOONING

Artists are those who can evade the verbose.

—HARUKI MURAKAMI

Art is a humanitarian act. Art should be able to affect mankind, to make the world a better place.

—JEFF KOONS

Art should be something like a good
armchair in which to rest from physical
fatigue.

—HENRI MATISSE

Art should be something that liberates
your soul, provokes the imagination, and
encourages people to go further.

—KEITH HARING

Art is the concrete artifact of faith and
expectation, the realization of a world that
would otherwise be little more than a veil
of pointless consciousness stretched over a
gulf of mystery.

—STEPHEN KING

A true artist is not one who is inspired, but one who inspires others.

—SALVADOR DALI

The purpose of art is mystery.

—RENE MAGRITTE

Art is a line around your thoughts.

—GUSTAV KLIMT

To photograph truthfully and effectively is to see beneath the surfaces and record the qualities of nature and humanity which live or are latent in all things.

—ANSEL ADAMS

Art doesn't have to be pretty. It has to be meaningful.

—DUANE HANSON

I want to die painting.

—PAUL CEZANNE

The artist must be a philosopher.

—Jacques-Louis David

In painting you must give the idea of the
true by means of the false.

—Edgar Degas

My work is very simple. My art reveals
idealism and truth.

—Francisco Goya

The function of art is to struggle against obligation.

—AMEDEO MODIGLIANI

I've never believed in God. But I believe in Picasso.

—DIEGO RIVERA

The role of art for me is the visualization of attitude, of the human attitude towards life, towards the world.

—JOSEF ALBERS

I paint a woman's big rounded buttocks
so that I want to reach out and stroke the
dimpled flesh.

—PETER PAUL RUBENS

Art is about paying attention.

—LAURIE ANDERSON

I can't tell you what art does and how it
does it, but I know that art has often judged
the judges, pleaded revenge to the innocent,
and shown to the future what the past has
suffered, so that it has never been forgotten.

—JOHN BERGER

It is an artist's duty to be on the wrong end of the see-saw.

—BILLY CHILDISH

If you ask me what I came to do in this world, I, an artist, will answer you: I am here to live out loud.

—EMILE ZOLA

The aim of every authentic artist is not to conform to the history of art, but to release himself from it in order to replace it with his own history.

—HAROLD ROSENBERG

All Artists are Anarchists.

—GEORGE BERNARD SHAW

Art is a microscope which the artist fixes on the secrets of his soul, and shows to people these secrets which are common to all.

—LEO TOLSTOY

Art is magic delivered from the lie of being truth.

—THEODOR W. ADORNO

Art is a guaranty of sanity. That is the most important thing I have said.

—Louise Bourgeois

I choose to reflect the times and the situations in which I find myself. How can you be an artist and not reflect the times?

—Nina Simone

Art is not a mirror held up to reality, but a hammer with which to shape it.

—Bertolt Brecht

I like to make an image that is so simple you can't avoid it, and so complicated you can't figure it out.

—ALEX KATZ

INTO
THE
UNKNOWN

Every artist is an intrepid explorer, pushing beyond the limits of the known and the familiar into uncharted territories. For some, this is the sacred mission of art. For others, it is a source of crushing anxiety.

But there are a few for whom brushing up against the profound is just part of the job. Nobody knows what makes good art, Alice Neel observed. As an artist, when it happens, you're grateful, and then you get on with it. No big deal at all.

Art is not the application of a canon of beauty but what the instinct and the brain can conceive beyond any canon. When we love a woman we don't start measuring her limbs.

—PABLO PICASSO

Art evokes the mystery without which the world would not exist.

—RENE MAGRITTE

A picture is a secret about a secret, the more it tells you the less you know.

—DIANE ARBUS

You cannot define electricity. The same can be said of art. It is a kind of inner current in a human being, or something which needs no definition.

—MARCEL DUCHAMP

To do a dull thing with style is preferable to doing a dangerous thing without it. To do a dangerous thing with style is what I call art.

—CHARLES BUKOWSKI

Whether you succeed or not is irrelevant, there is no such thing. Making your unknown known is the important thing— and keeping the unknown always beyond you.

—GEORGIA O'KEEFE

An artist is someone who produces things that people don't need to have but that he—for some reason—thinks it would be a good idea to give them.

—ANDY WARHOL

Go and make interesting mistakes, make amazing mistakes, make glorious and fantastic mistakes. Break rules. Leave the world more interesting for your being here. Make. Good. Art.

—NEIL GAIMAN

Everyone discusses my art and pretends to understand, as if it were necessary to understand, when it is simply necessary to love.

—CLAUDE MONET

I never paint dreams or nightmares. I paint my own reality.

—FRIDA KAHLO

Without tradition, art is a flock of sheep without a shepherd. Without innovation, it is a corpse.

—WINSTON CHURCHILL

If all the world were clear, art would not exist.

—ALBERT CAMUS

Painting something that defies the law of the land is good. Painting something that defies the law of the land and the law of gravity at the same time is ideal.

—BANKSY

The position of the artist is humble. He is essentially a channel.

—Piet Mondrian

I shut my eyes in order to see.

—Paul Gauguin

What you do when you paint, you take a brush full of paint, get paint on the picture, and you have faith.

—Willem De Kooning

Creativity takes courage.

—HENRI MATISSE

The job of the artist is always to deepen the mystery.

—FRANCIS BACON

Now there are no priests or philosophers left, artists are the most important people in the world.

—GERHARD RICHTER

Surrealism is destructive, but it destroys only what it considers to be shackles limiting our vision.

—SALVADOR DALI

Every painting is a voyage into a sacred harbor.

—GIOTTO DI BONDONE

More of me comes out when I improvise.

—EDWARD HOPPER

I could paint for a hundred years, a thousand years without stopping and I would still feel as though I knew nothing.

—PAUL CEZANNE

We declare…that the name of 'madman' with which it is attempted to gag all innovators should be looked upon as a title of honor.

—UMBERTO BOCCIONI

There is only one thing valuable in art; the thing you cannot explain.

—GEORGES BRAQUE

I dream my painting and I paint my dream.

—VINCENT VAN GOGH

Art is either revolution or plagiarism.

—PAUL GAUGUIN

Only when he no longer knows what he is doing does the painter do good things.

—EDGAR DEGAS

Everything vanishes around me, and works are born as if out of the void. Ripe, graphic fruits fall off. My hand has become the obedient instrument of a remote will.

—PAUL KLEE

The expression of human feelings and the passions of man certainly interest me deeply, but I am less concerned with expressing the motions of the soul and mind than to render visible, so to speak, the inner flashes of intuition which have something divine in their apparent insignificance and reveal magic, even divine horizons…

—GUSTAVE MOREAU

Have you ever seen an inch worm crawl up a leaf or twig, and then clinging to the very end, revolve in the air, feeling for something to reach? That's like me. I am trying to find something out there beyond the place on which I have a footing.

—ALBERT PINKHAM RYDER

All painting is an accident. But it's also not an accident, because one must select what part of the accident one chooses to preserve.

—FRANCIS BACON

When I paint, my work manifests the unexpected...

—PIERRE ALECHINSKY

Painting is a language which cannot be replaced by another language. I don't know what to say about what I paint, really.

—BALTHUS

It is the mysterious that I love in painting. It is the stillness and the silence. I want my pictures to take effect very slowly, to obsess and to haunt.

—WILLIAM BAZIOTES

If you're any kind of artist, you make a miraculous journey, and you come back and make some statements in shapes and colors of where you were.

—ROMARE BEARDEN

Nearly every artist continually wants to reach the edge of nothingness—the point where you can't go any further.

—HARRY CALLAHAN

'Artist' refers to a person, willfully enmeshed in a dilemma of categories, who performs as if none of them existed.

—ALLAN KAPROW

Artists today think of everything they do as a work of art. It is important to forget about what you are doing—then a work of art may happen.

—ANDREW WYETH

Art is an effort to make you walk a half an inch above ground.

—YOKO ONO

EMOTION,
INCARNATE

reat art demands that artists and viewers alike make themselves vulnerable as they struggle to understand one another. Yet vulnerability brings the risk of pain, of misunderstanding. The painter makes real to others his innermost feelings about all that he cares for, observed Lucian Freud. A secret becomes known to everyone who views the picture through the intensity with which it is felt.

Revealing our deepest secrets can hurt. How much? In a Weimar-era poster, Oskar Koskoschka famously portrayed a figure fingering an open wound in his chest. Art is self-sacrifice, he implied, but do we really have any choice in the matter?

You use a glass mirror to see your face; you use works of art to see your soul.

—GEORGE BERNARD SHAW

A man's work is nothing but this slow trek to rediscover, through the detours of art, those two or three great and simple images in whose presence his heart first opened.

—ALBERT CAMUS

To paint is to love again, live again, see again. To get up at the crack of dawn in order to take a peek at the water colors one did the day before, or even a few hours before, is like stealing a look at the beloved while she sleeps.

—HENRY MILLER

Every good painter paints what he is.

—JACKSON POLLOCK

I don't think of myself as making art. I
do what I do because I want to, because
painting is the best way I've found to get
along with myself.

—Robert Rauschenberg

Art attracts us only by what it reveals of our
most secret self.

—Jean-Luc Godard

You don't make art out of good intentions.

—Gustave Flaubert

The primary distinction of the artist is that he must actively cultivate that state which most men, necessarily, must avoid: the state of being alone.

—JAMES BALDWIN

The main thing is to be moved, to love, to hope, to tremble, to live.

—AUGUSTE RODIN

The whole culture is telling you to hurry, while the art tells you to take your time. Always listen to the art.

—JUNOT DIAZ

Painting is just another way of keeping a diary.

—Pablo Picasso

Practicing an art, no matter how well or badly, is a way to make your soul grow, for heaven's sake. Sing in the shower. Dance to the radio. Tell stories. Write a poem to a friend, even a lousy poem. Do it as well as you possibly can. You will get an enormous reward. You will have created something.

—Kurt Vonnegut

One hundred artists introduce us to one hundred worlds.

—William Baziotes

The act of painting is about one heart telling another heart where he found salvation.

—FRANCISCO GOYA

No great artist ever sees things as they really are. If he did, he would cease to be an artist.

—OSCAR WILDE

Artmaking is making the invisible, visible.

—MARCEL DUCHAMP

Art completes what nature cannot bring
to finish. The artist gives us knowledge of
nature's unrealized ends.

—ARISTOTLE

When one is painting one does not think.

—RAPHAEL

All art is erotic.

—GUSTAV KLIMT

Art cannot be modern. Art is primordially eternal.

— EGON SCHIELE

It is well with me only when I have a chisel in my hand.

—MICHELANGELO

No, I don't believe in genius. I believe in freedom. I think anyone can do it. Anyone can be like Rembrandt.

—DAMIEN HIRST

The ideal artist is he who knows everything, feels everything, experiences everything, and retains his experience in a spirit of wonder and feeds upon it with creative lust.

—GEORGE BELLOWS

Draw your pleasure, paint your pleasure, and express your pleasure strongly.

—PIERRE BONNARD

I paint my own reality. The only thing I know is that I paint because I need to, and I paint whatever passes through my head without any other consideration.

—FRIDA KAHLO

Every work of art is the child of its time;
often it is the mother of our emotions.]

—WASSILY KANDINSKY

With one eye you are looking at the outside
world, while with the other you are looking
within yourself.

—AMEDEO MODIGLIANI

The artist need not know very much; best
of all let him work instinctively and paint as
naturally as he breathes or walks.

—EMIL NOLDE

True art lies in a reality that is felt.

 —Odilon Redon

For me, painting is a way to forget life. It is a cry in the night, a strangled laugh.

 —Georges Rouault

A painting, if the light is just so, can turn into a luminescent inferno which may reveal for just a moment the soul of the artist.

 —Peter Paul Rubens

Artists create out of a sense of desolation.
The spirit of creation is an excruciating,
intricate exploration from within the soul.

—EL GRECO

What the rest of us see only under
the influence of mescaline, the artist is
congenitally equipped to see all the time.

—ALDOUS HUXLEY

All art is autobiographical; the pearl is the
oyster's autobiography.

—FEDERICO FELLINI

If you could say it in words there would be
no reason to paint.

—EDWARD HOPPER

The aim of art is to represent not the
outward appearance of things, but their
inward significance.

—GEORGE BELLOWS

An artist cannot speak about his art any
more than a plant can discuss horticulture.

—JEAN COCTEAU

As an artist, you reach for the pen that's full of blood.

—PAUL MONETTE

Art is really a battle.

—EDGAR DEGAS

A work of art is the trace of a magnificent struggle.

—ROBERT HENRI

STRIVING
FOR
PERFECTION

The aging Japanese artist Hokusai understood his life as one long art lesson. At seventy-three, he recalled, I learned a little about the real structure of animals, plants, birds, fishes and insects. Consequently, when I am eighty I'll have made more progress. At ninety I'll have penetrated the mystery of things. At a hundred I shall have reached something marvelous, but when I am a hundred and ten everything I do, the smallest dot, will be alive.

To create art is to strive for impossible eloquence, for the ability to make even the smallest detail hum with what feels like life. To achieve that goal is what we might call perfection; to fall short is to be all too human.

Well, art is art, isn't it? Still, on the other hand, water is water! And east is east and west is west and if you take cranberries and stew them like applesauce they taste much more like prunes than rhubarb does.

—GROUCHO MARX

Art is not what you see, but what you make others see.

—EDGAR DEGAS

Don't think about making art, just get it done. Let everyone else decide if it's good or bad, whether they love it or hate it. While they are deciding, make even more art.

—ANDY WARHOL

The little dissatisfaction which every artist feels at the completion of a work forms the germ of a new work.

—BERTHOLD AUERBACH

The true gourmet, like the true artist, is one of the unhappiest creatures existent. His trouble comes from so seldom finding what he constantly seeks: perfection.

—Ludwig Bemelmans

Life is the art of drawing without an eraser.

—John Gardner

Self-consciousness is the enemy of all art, be it acting, writing, painting, or living itself, which is the greatest art of all.

—Ray Bradbury

If it were not for the intellectual snobs who pay—in solid cash—the tribute which philistinism owes to culture, the arts would perish with their starving practitioners. Let us thank heaven for hypocrisy.

—ALDOUS HUXLEY

I don't believe in total freedom for the artist. Left on his own, free to do anything he likes, the artist ends up doing nothing at all. If there's one thing that's dangerous for an artist, it's precisely this question of total freedom, waiting for inspiration and all the rest of it.

—FEDERICO FELLINI

A great artist is always before his time or behind it.

—GEORGE MOORE

There's no such thing as perfect writing, just like there's no such thing as perfect despair.

—HARUKI MURAKAMI

The true work of art is but a shadow of the divine perfection.

—MICHELANGELO

I don't think there's any artist of any value who doesn't doubt what they're doing.

—FRANCIS FORD COPPOLA

Every genuine work of art has as much reason for being as the earth and the sun.

—RALPH WALDO EMERSON

You can't make a perfect painting. We can see perfection in our minds. But we can't make a perfect painting.

—AGNES MARTIN

It doesn't matter how the paint is put on, as long as something is said.

—JACKSON POLLOCK

An artist is forced by others to paint out of his own free will.

—WILLEM DE KOONING

Painting is the grandchild of nature. It is related to God.

—REMBRANDT

The more I paint the more I like everything.

—JEAN-MICHEL BASQUIAT

Art is never finished, only abandoned.

—LEONARDO DA VINCI

Whenever I see a Frans Hals, I feel the desire to paint; but when I see a Rembrandt, I want to give it up.

—MAX LIEBERMANN

Make a drawing. Start all over again. Trace it.
Start it and trace it again. You must do over
the same subject ten times, a hundred times.
In art nothing must appear accidental even a
movement.

—EDGAR DEGAS

Artists who seek perfection in everything
are those who cannot attain it in anything.

—EUGÈNE DELACROIX

Cover the canvas at the first go, then work
at it until you see nothing more to add.

—CAMILLE PISSARRO

They see poetry in what I have done. No.
I apply my methods, and that is all there is
to it.

—GEORGES SEURAT

Nothing is simpler than to complete
pictures in a superficial sense. Never does
one lie so cleverly as then.

—HENRI DE TOULOUSE-LAUTREC

Good painting is like good cooking; it can
be tasted, but not explained.

—MAURICE DE VLAMINCK

I paint every day. Sometimes I hate painting, but I keep at it, thinking always that before I croak I'll really learn how to do it.

—THOMAS HART BENTON

Bring something new, something beautiful and something filled with light into the world.

—ROSS BLECKNER

To create art means to be crazy alone forever.

—CHARLES BUKOWSKI

The need to be a great artist makes it hard to be an artist. The need to produce a great work of art makes it hard to produce any art at all.

—Julia Cameron

All artists are two-headed calves.

—Truman Capote

He who desires nothing, hopes for nothing, and is afraid of nothing, cannot be an artist.

—Anton Chekhov

After a certain high level of technical skill
is achieved, science and art tend to coalesce
in esthetics, plasticity, and form. The greatest
scientists are artists as well.

—ALBERT EINSTEIN

An artist is a creature driven by demons—
he usually doesn't know why they chose
him and he's usually too busy to wonder
why.

—WILLIAM FAULKNER

A good artist has less time than ideas.

—MARTIN KIPPENBERGER

Art comes to you proposing frankly to give nothing but the highest quality to your moments as they pass.

—WALTER PATER

Art is the elimination of the unnecessary.

—PABLO PICASSO

Art is too serious to be taken seriously.

—AD REINHARDT

I have offended God and mankind because my work didn't reach the quality it should have.

—Leonardo Da Vinci

CREATING
BEAUTY

Training, technique, inspiration, circumstance—these are all part of the artist's palette as she seeks to approximate beauty, to somehow embody it on canvas or clay. Most would agree that chance also plays a role. For the artist, John Berger observed, drawing is discovery. And that is not just a slick phrase; it is quite literally true.

Discovery. In other words, a willingness to be open to the unknown and the unanticipated. In this sense, beauty is not so much created as encountered, like a clearing in familiar woods that you never knew existed…but are overjoyed to have stumbled upon.

But you must be prepared to recognize it.

CREATING
BEAUTY

Training, technique, inspiration, circumstance—these are all part of the artist's palette as she seeks to approximate beauty, to somehow embody it on canvas or clay. Most would agree that chance also plays a role. For the artist, John Berger observed, drawing is discovery. And that is not just a slick phrase; it is quite literally true.

Discovery. In other words, a willingness to be open to the unknown and the unanticipated. In this sense, beauty is not so much created as encountered, like a clearing in familiar woods that you never knew existed…but are overjoyed to have stumbled upon.

But you must be prepared to recognize it.

Beauty will be convulsive or will not be at all.

—ANDRE BRETON

To be an artist means never to avert one's eyes.

—AKIRA KUROSAWA

When I say 'artist' I mean the man who is building things...It's all a big game of construction—some with a brush—some with a shovel—some choose a pen.

—JACKSON POLLOCK

Great things are done by a series of small things brought together.

—Vincent Van Gogh

There are painters who transform the sun to a yellow spot, but there are others who, with the help of their art and their intelligence, transform a yellow spot into sun.

—Pablo Picasso

The art of art, the glory of expression, and the sunshine of the light of letters, is simplicity.

—Walt Whitman

It starts with this: put your desk in the
corner, and every time you sit down there
to write, remind yourself why it isn't in
the middle of the room. Life isn't a support
system for art. It's the other way around.

—STEPHEN KING

When it is working, you completely go into
another place, you're tapping into things
that are totally universal, completely beyond
your ego and your own self. That's what it's
all about.

—KEITH HARING

The way to create art is to burn and destroy ordinary concepts and to substitute them with new truths that run down from the top of the head and out of the heart.

—CHARLES BUKOWSKI

The world is but a canvas to the imagination.

—HENRY DAVID THOREAU

A painting is finished when the artist says it is finished.

—REMBRANDT

Anything is art if an artist says it is.

—MARCEL DUCHAMP

Art is something that happens inside us. We look at things in the world, and we become excited by them. We understand our own possibilities of becoming. And that's what art is.

—JEFF KOONS

A man paints with his brains and not with his hands.

—MICHELANGELO

I make pictures and someone comes in and calls it art.

—WILLEM DE KOONING

In our time there are many artists who do something because it is new; they see their value and their justification in this newness. They are deceiving themselves; novelty is seldom the essential. This has to do with one thing only; making a subject better from its intrinsic nature.

—HENRI DE TOULOUSE LAUTREC

To hinder an artist is a crime, to do so is to murder burgeoning life.

—EGON SCHIELE

For me there is no difference between art and life.

—ROBERT RAUSCHENBERG

Sometimes I do get to places just when God's ready to have somebody click the shutter.

—ANSEL ADAMS

Painting is easy when you don't know how, but very difficult when you do.

—Edgar Degas

A beautiful body perishes, but a work of art dies not.

—Leonardo Da Vinci

I would rather be the first painter of common things than second in higher art.

—Diego Velázquez

The precision of naming takes away from the uniqueness of seeing.

—PIERRE BONNARD

I always pet a dog with my left hand because if he bit me I'd still have my right hand to paint with.

—JUAN GRIS

A good painting is true to itself.

—EDOUARD MANET

Blessed are they who see beautiful things in humble places where other people see nothing.

—CAMILLE PISSARRO

I'm just a simple man standing alone with my old brushes, asking God for inspiration.

—PETER PAUL RUBENS

Every picture shows a spot with which the artist himself has fallen in love.

—ALFRED SISLEY

As light fades and the shadows deepen, all petty and exacting details vanish, everything trivial disappears, and I see things as they are in great strong masses: the buttons are lost, but the sitter remains; the sitter is lost, but the shadow remains; the shadow is lost, but the picture remains. And that, night cannot efface from the painter's imagination.

—JAMES ABBOTT MCNEILL WHISTLER

Artists are the people among us who realize creation didn't stop on the sixth day.

—JOEL PETER WITKIN

The painting has a life of its own.

—JACKSON POLLOCK

I want the shuffles and echoes, and a certain mysteriousness…It's so bloody hard to paint.

—LELAND BELL

What any true painting touches is an absence—an absence of which without the painting, we might be unaware. And that would be our loss.

—JOHN BERGER

Even the act of peeling a potato can be an artistic act if it is consciously done.

—JOSEPH BEUYS

Artists are like cockroaches; everything is grist for the mill.

—ELAINE DE KOONING

I have never been able to understand the artist whose image never changes.

—LEE KRASNER

Artists do not run away from non-being, but by encountering and wrestling with it, force it to produce being.

—ROLLO MAY

An artist earns the right to call himself a creator only when he admits to himself that he is but an instrument.

—HENRY MILLER

All important things in art have always originated from the deepest feeling about the mystery of Being.

—MAX BECKMANN

Art is the means we have of undoing the damage of haste. It's what everything else isn't.

—THEODORE ROETHKE

AFTERWORD

Of all the things that set mankind apart from the rest of the world, their ability to both create and appreciate art is perhaps the most significant. The greatest minds of each generation have tried to understand art, how it works, and why it has such a profound effect on us.

But true art is beyond any single description. Even the words collected here are a mere fraction of the incredible, immutable thing we call "art." So I invite each of you to fill your life with all that art has to offer, and in doing so, discover just what it means to be an "art lover."